10

11

12

13

14

15

People I've never met &
Conversations I've never had.

NICK WHITE

nobrow Press.

HELLO.

L...

Hello!

Nice Pyjamas!

Thanks. They're yours

They're not my Pyjamas. Mine have Rockets + those hav teddys. Also Mine are blue not pink like those. Also also mine are adult size and those a kids size.

so these aren't your

No.

But they were in yo drawers, in your bedroom, in your hou

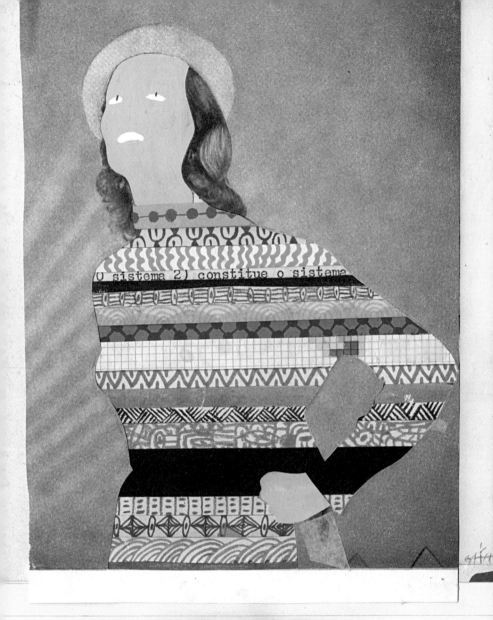

MARIA ELENA.

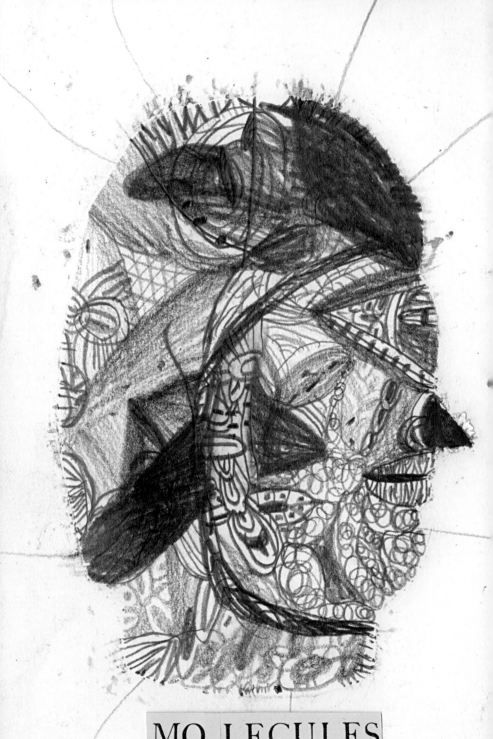

MO LECULES

Untidy balls of string?

ELGAR W

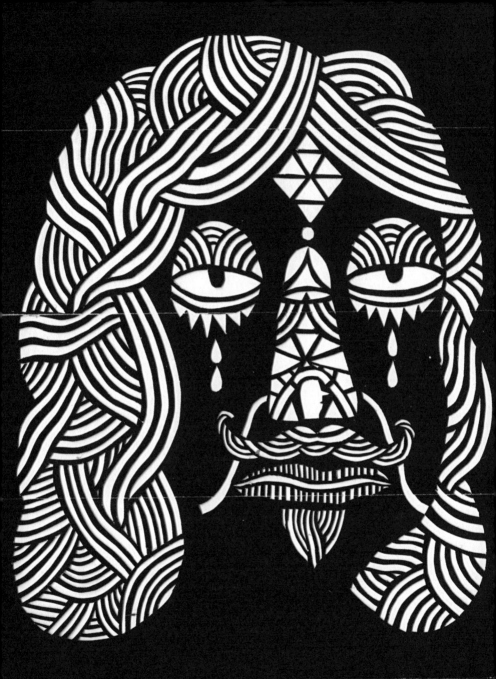

WILL FLAVOUR

What's that sticking out of your neck?

"My head?"

"Good one. No what is that? It's huge."

"It's my head."

"No, that thing with hair on it and those weird fleshy things sticking out the sides."

"That is my head and those fleshy things are my ears."

"Well whatever it is, it's fucking gross."

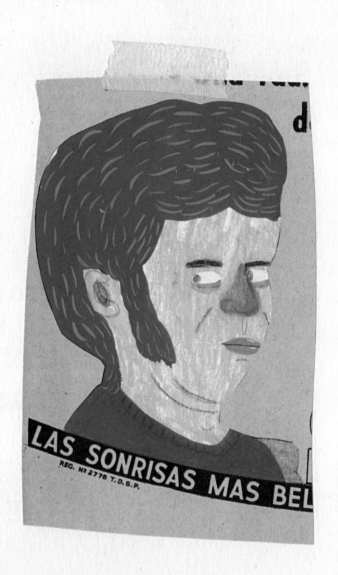

ROBERT COUGHLAN

What's with all the Camouflage? Going Hunting WHAT? Can you see me? Very good. You going paintballing or something? You can really see me can't you? The man in the shop said I'd be invisible. No I can clearly see you. Maybe he meant in the woods.

Perhaps. I feel a bit stupid now. Does this mean I have to pay for my bus fare now? yes it does i'm afraid. That will be two eighty please. -------Ta.

AL DRUDGERY

"Did the Microscope Work?"
"Yeah I pricked my Finger
and dropped a Few drops
Of blood on the glass Plate."
"What did you See?"
"It was weird, all moving
about and stuff."
"Blood cells Probably,
Shifting around."
"That's Odd. I thought
you'd just see red.
Like red but really
close up red."

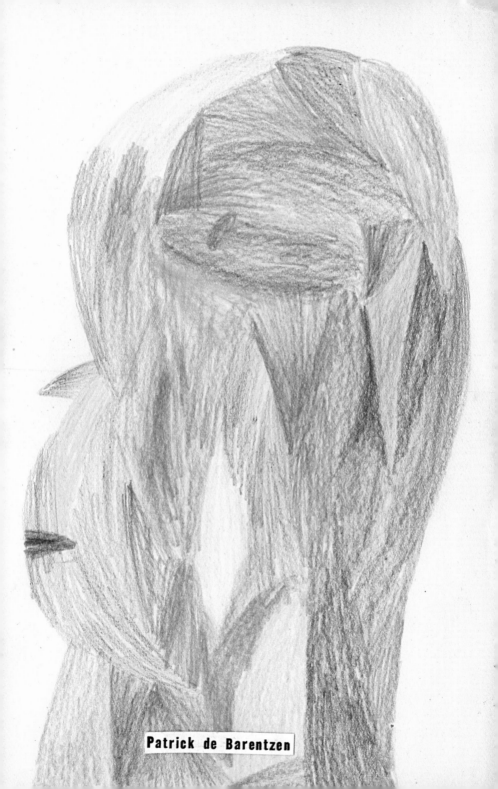

Patrick de Barentzen

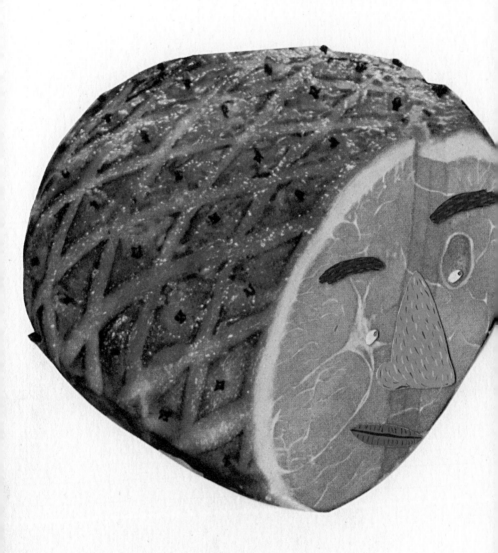

Miss America

MR. CLEVELAND

Robert-Murray

MRS. HILDA LYNN OF LONG ISLAND

Did you watch the Boxing Last night?

No. Who was fighting

Me and my brother.

Right. Who won?

Well let's just say one of us isn't going to be walkin for a while.

You lost then?

YES.

V. M. FitzRoy

What did you just say?

SORRY?

Damn right you're sorry. Say something like that again and you'll be apologizing all over the shop.

WHAT?

Don't play dumb with me I heard what you said, as everyone else here did.

I didn't say anything.

Oh......Didn't you? Sorry about that I must have misheard you I swear you called my mum a "soapy bubble bath monster" Oh dear I feel a little silly now.

✳

Phillip

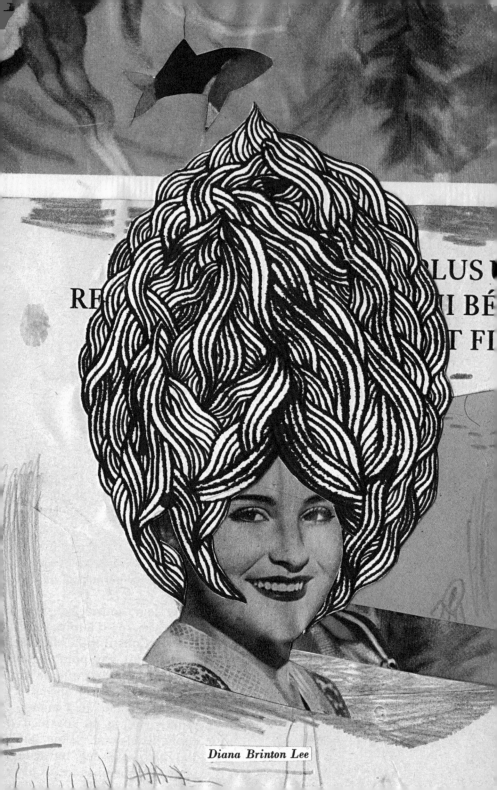

Diana Brinton Lee

AUGUSTUS FRIEND

Chief

LEE., PORTSMOUTH

'DAN DERINE'

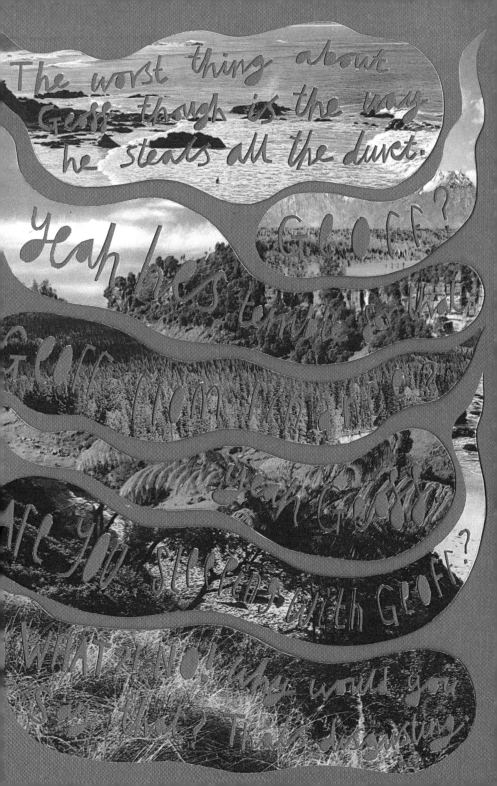

and This One Time...
i ran so fast my trainers Actually Melted.

BULLSHIT!

Well they did, So...

You are such a liar!

yeah well, come over one day and I'll show you.

OK. Let's go NOW.

What? i am quite busy but give me an hour or So and then we can see who the liar is.

EVEN

ODD

1 3 5 7 9 11 13

It's you. You're the liar.

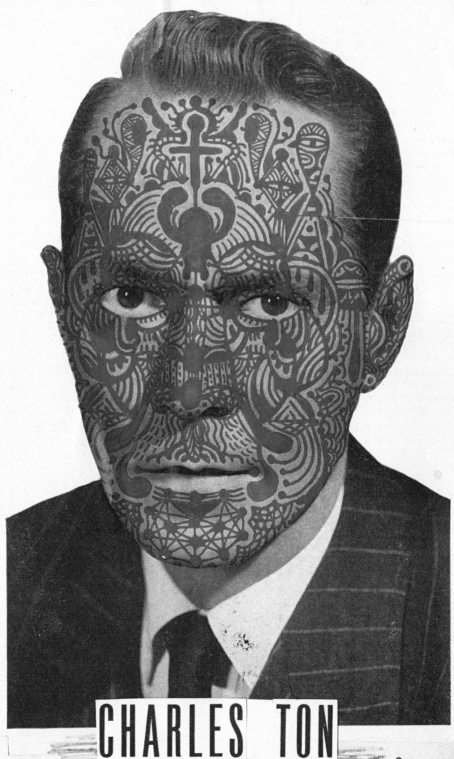

CHARLES TON

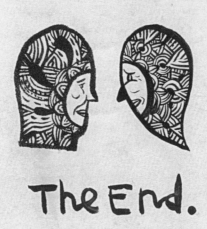

The End.

Editing, Art direction and Design: Sam Arthur + Alex Spiro

Published by Nobrow Ltd. 62 Great Eastern Street, London EC2A 3QR.
Printed in Belgium by Proost
ISBN: 978-0-9562135-1-8

. Visit WWW. nobrow.net